D1083149

Painting Children

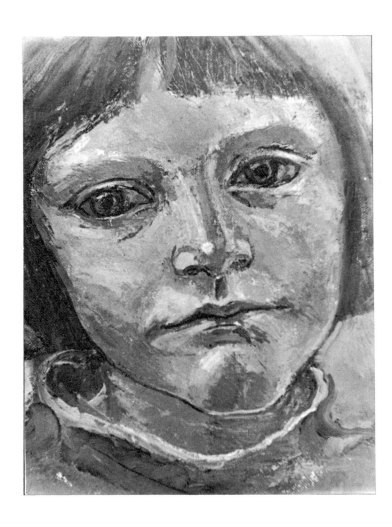

Painting Children

Benedict Rubbra

Studio Vista London
Watson-Guptill Publications New York

General Editors Janey O'Riordan and Brenda Herbert
© Benedict Rubbra 1968
Published in London by Studio Vista Limited
Blue Star House, Highgate Hill, London N19
and in New York by Watson-Guptill Publications
165 West 46th Street, New York 10036
Library of Congress Catalog Card Number 68-26320
Distributed in Canada by General Publishing Co. Ltd
30 Lesmill Road, Don Mills, Toronto, Canada
Set in Univers medium 9/11 point
by V. Siviter Smith and Co. Ltd, Birmingham
Printed in the Netherlands
by N. V. Grafische Industrie Haarlem
SBN 289. 37069. 8

Contents

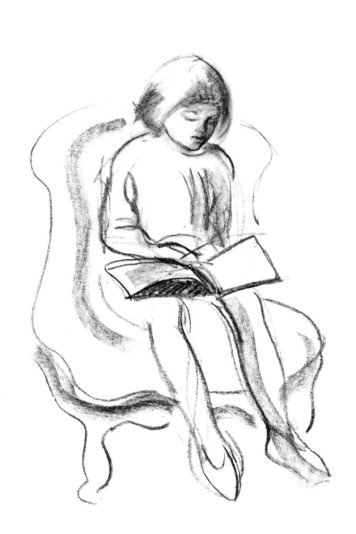

1 Preamble

Basically, painting is about the problems of seeing; and so the eye, and how we see, is the first consideration.

The main joy of painting — apart from recording on canvas something we love or have reacted to strongly in some way — is that we learn to see better and so experience more and more visual pleasure when looking around us; and, as we continue to paint, the enjoyment will increase. We see exciting shapes and colours that we would not have dreamed possible before we began to paint — perhaps the dark lines of branches in a tree forming an expanding rhythm, or two shapes in the sky that surround a building and press against each other.

The painter, whether he is doing landscape, still-life or portraits, must always be learning how to see colours, shapes and movement in relation to each other. The eyes must be kept alert. The painter must also have a knowledge about how shapes are made and how colours react. This knowledge, however, can be dangerous, because it may fill us with preconceived ideas and therefore blind us to many visual possibilities; but it is important because we must always know what to look for. For example, if a table is drawn with a preconceived idea about the shape (knowing that the top is rectangular) then the chances are that the table in the drawing will appear to be tipping up. Knowledge of perspective (lines meeting at a common point) will indicate what to look for, and so the shape of the table will be drawn correctly. It helps us to draw an apple if we know that the surface shape always has five main changes in direction, but to think that apples are red or green prevents us from seeing the actual colour. This problem of seeing what we know, and what we think we know, must be considered very seriously.

As an athlete must train his body so that he can jump or run higher or faster, so the painter must train his eyes so that he can see with more life and excitement. When painting a portrait of a child, in particular, the eye has to be as alert and penetrating as a

hawk's. Neither a child's body nor his expression is ever static, so we have to observe and remember.

The importance of memory is illustrated by my experience of painting a child aged four. For the initial ten minutes, while the admonitions of his parents were still fresh in his mind, he sat with unusual stillness. Gradually he began to move as if he was slowly waking up. His attention began to be fixed with ever increasing affection on the paint being squeezed out of the tubes. From then on I realised that it would be impossible to get him to pose in the position which I had first intended. His inhibitions finally broke down and his one ambition was to watch me painting him, and he discovered that the most advantageous place was to be wedged between my back and the back of the chair. What could I do? The only thing was to look and remember. This is an extreme example (or I hope it is for your sake), but it does show you how important it is to develop your memory in terms of colour, tone and shape.

Although this book is primarily concerned with the basic points to look for when tackling a portrait of a child, try to paint as many other kinds of pictures as possible to increase your powers of observation. Be your own critic, and as severe as possible. Be prepared to scrap a picture as soon as you feel in any way displeased with it, because this is a sure way of improving and not just continuing on the same track. In one sense it is harder for the amateur painter to make continued progress, because a period of weeks or even months may pass between painting sessions, and it is easy to lose what you have learned if there is a long interval. Try to set aside a regular time for painting and be quite ruthless if someone attempts to disturb you.

Finally, it is useful to look at as many portraits of children by great painters as possible. If the original is out of reach there are plenty of books with excellent reproductions. The value of this is to compare the different styles and note the enormous difference in approach between, say, Rembrandt and Renoir. It will help you to realize that it is quite possible to vary your approach and so make your painting more alive. Not only must you paint a portrait of a child but also make it *your* painting.

Painting should always be a joy to do, and it is rewarding to record on canvas something you love; but when a picture is good

enough to hang on the wall, there is a delightful sense of achievement. This sense of achievement, which really is the most important aspect of painting, can only be experienced if you are prepared to struggle along and have black days when nothing seems to go as you want. I can assure you that to win through after a black period is really something quite beautiful!

We will start with some exercises for the eyes, some 'arpeggios'. These should be exciting to do—and remember that you have to be fit to tackle any problem.

2 Learning to see—exercises

Forms, colours, and tones cease to have any meaning if they are isolated from their environment. The moon would lose all its mystery if it were not seen as part of the infinite expanse of space. It is impossible to imagine the open horizon without the sky, or dark without light. There would be no melody without the relationship of notes; and so when painting you must see all things together.

The following exercises are aimed at making you see things in relation to each other. Your task is to paint animated and moving forms, and you will not have many opportunities to work out proportions and colour and tone relationships as the painting is progressing. You must develop a technique of seeing, so that it is possible to assess these relationships immediately, and so be able to understand what happens when, for example, expressions change. This particular understanding will give you clues about the child's personality, and make it possible to achieve a feeling of spontaneity in your portrait, which is so vital when painting a child.

Seeing several shapes as a whole

Here is the first exercise. Pin onto a plain wall or screen some simple shapes cut out of white paper—about nine shapes covering an area of approximately nine square feet (fig. 1). The distance between these shapes and yourself is important. You must place yourself at a distance which will force you to see the group as a whole. Get as near as possible and make the angle of vision more than 60° (fig. 2). This exercise is aimed at making you see whole areas together, and the drawing must be done in the correct way.

First of all it would be wrong to start by drawing just one of the shapes and then move on to the next shape, and so on. The overall shape of the group must be the first consideration. To help you decide the overall shape, imagine a length of string

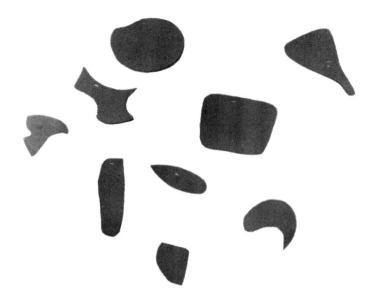

Fig. 1

enclosing the group (fig. 3). Begin the drawing by plotting out
the shape of the group, then find the centre and gradually work
outwards, trying to keep all the shapes at the same stage of com-
pletion. Soon you will discover that the spaces between the
shapes are as important as the shapes themselves (fig. 4).

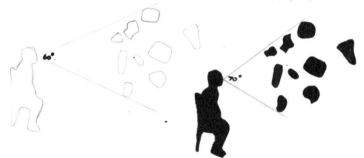

Fig. 2 Take up a position which will force your eyes to see over a wide area

11

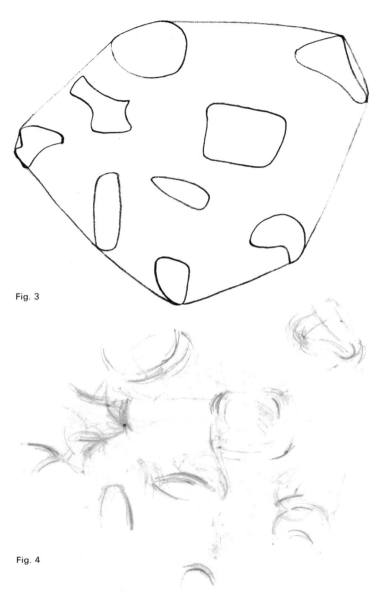

Fig. 3

Fig. 4

12

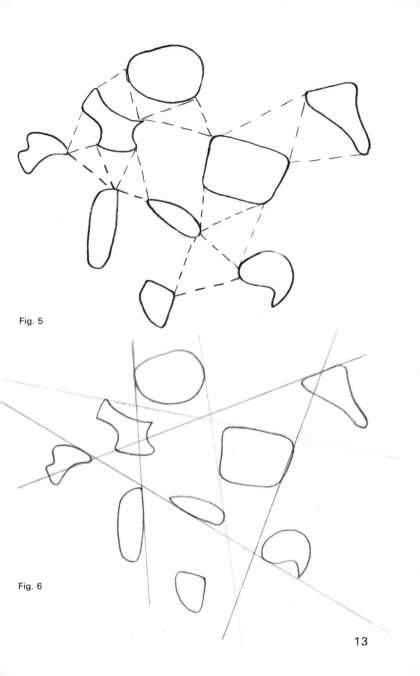

Fig. 5

Fig. 6

13

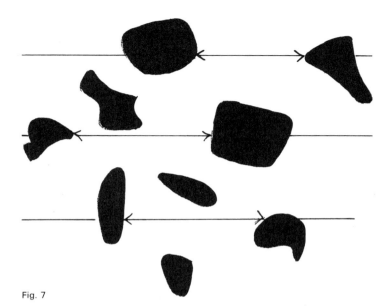

Fig. 7

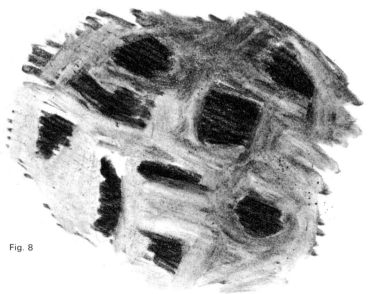

Fig. 8

Another way to help you to see the complete group is to form triangles by finding three salient points from three of the paper shapes. Again it is a help to continue the direction of one contour and discover where it meets other shapes. Every so often you must stop the movement of your pencil, keeping it on the paper and then moving your eye about the group so that you see beyond the point that you happen to be drawing. By doing this you will force your eye to look at more than one thing at a time (figs 5 and 6).

Now, it is very easy to think that you have drawn all this correctly, but it would be defeating the purpose of the exercise to make any concessions. Check your drawing by marking about three horizontal and parallel lines over the shapes that are on the wall so that you can see if you have drawn the correct distances between each shape (fig. 7).

You cannot expect to record all the subtleties of a child's changing expression without a large repertoire of techniques for seeing; so variety in the way you look at things will help you with the portrait. With the same group in front of you, cover your sheet of paper with charcoal and draw the spaces between the paper shapes by using a rubber (gum eraser) (fig. 8).

Seeing relationships

The first exercise was done with random shapes to prevent your being conditioned by the actual thing you were drawing. (Remember what I have said about the dangers of drawing with pre-conceived ideas). With the next exercise you can move on to something more familiar.

Find two stools or chairs and arrange them against a window so that the light is shining through them. As with the spaces between the shapes in the first exercise, you will now realise how important it is to look for all the shapes of light that you see through the chairs. Just draw these shapes of light (but not the actual chairs), trying all the time to get the proportions of each shape correct. After some time your eyes will become tired from having been forced to see several shapes together. When this happens you will know that you have really been using them. Now sit in front of the same group and draw without taking your

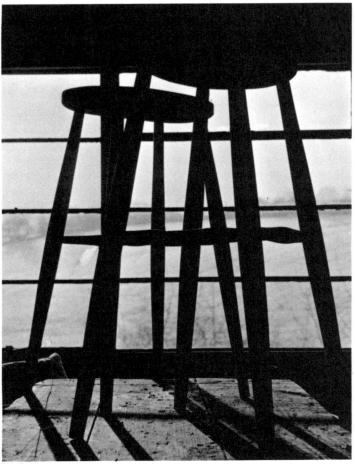

Fig. 9

pencil off the paper. First you can try just drawing the outline (fig. 11); then begin another drawing of the chairs and shapes of light (fig. 12). You can, of course, draw over the previous lines several times. Again, the purpose of never lifting your pencil off the paper is to force your eyes always to look beyond the actual

Fig. 10

Fig. 11

point you are drawing, so that it will gradually become natural for you to see more than one thing at a time; in other words, to see things in relationship. It will also help you to see rhythms in the body and head of a child. Obviously, carrying out these exercises just once won't give you all the necessary information for painting a portrait of a child. Do them as many times as possible. Really make sure that you have drawn correctly, and persevere until this is achieved. Otherwise the point of the exercise—to limber up your eyes—is lost.

Seeing colour and tone

The next exercise is to help you to understand colour and tone. On a table arrange four bricks that have been painted white (with emulsion paint or whitewash) and place them on a piece of white paper, with another piece of folded white paper as a background. Try to have the light coming from either the left or right. The fact

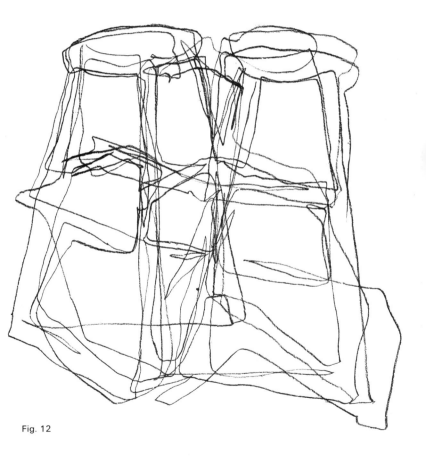

Fig. 12

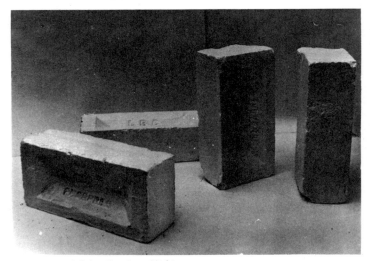

Fig. 13 Note definite direction of light

that you know the bricks and background are white will prevent you from seeing the different tones, unless you are prepared to see them only in terms of colour and tone. The chances are that when you start a portrait you will be biased by what you think you know about the colours and tones of a face, particularly if the face is moving and you are tempted to do a lot of guessing.

Figs. 14, 15, 16 Understand the shape of the group and then experiment with composition

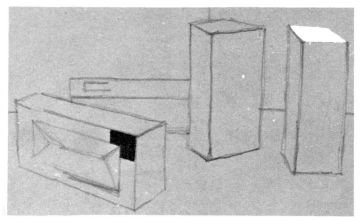

Fig. 17

Having decided how you will arrange the composition, you must first discover which is the lightest part of your picture, and which the darkest. (This, and the rest of the exercise, must be done very methodically.) Then think about the colour. Discover the warmest area (that which tends towards red) and then the coldest (tending towards blue). You have now established the limits of the colour and tone scales. From now on force yourself

Fig. 18

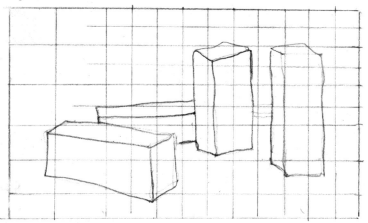

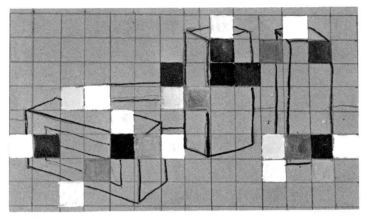

Fig. 19

to see the colours and tones in pairs; in other words, paint a colour and its immediate neighbour as simultaneously as possible. To make yourself see even more clearly in terms of colour and tone, and to prevent yourself from making a representational painting of bricks, cover your canvas with a grid (forming 2" squares) and then paint in two of the squares as simultaneously as possible. To get the correct relationship of all the squares will be very difficult and you will have do do a lot of juggling (see figs 14–19).

Seeing form

Next let us study the shape of an apple. It is very important to acquire a sound store of knowledge about form. If you can really understand how the form of the head works and have a scheme to discover this form, then the portrait you are attempting will assume a positive quality that will give the painting strength. So it would be useful at this point for you to analyse shapes and discover for yourself the structure of some simple forms. The most important point to find in any three-dimensional form is where the change of plane takes place. If you cut an apple in half and trace the contour on a piece of paper you will find that on this contour

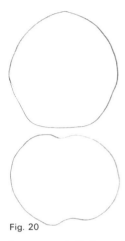

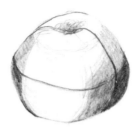

Fig. 20

there are definite points where the line changes direction. Cut a similar kind of apple on the opposite axis and make another tracing; and now look at an apple knowing that there are five definite changes of plane. If you make a painting or drawing of

Fig. 21

the apple, the first point to notice is that the tones change very definitely where the changes of plane occur (fig. 20).

At this point in our series of exercises you will notice that we have gradually progressed towards a form that is similar to that of a head. The different ways of looking at a head should be positively related to these exercises (fig. 24).

Fig. 22

It would now be helpful to work with a piece of clay so that you will understand the important factors of a form not only by sight, but also by touch. After studying the apple, make a model of it just by using the two contours previously traced. You will understand the importance of making changes of direction when you find it is difficult to model a simple form into a positive shape. Another useful exercise would be to find a simple rounded stone and draw over the main changes of direction with a pencil. Then make a model of the stone (figs 21–23).

Fig. 23

Fig. 24 The main changes of direction are marked. Note the same number of changes as on the apple, p. 23

3 Exercises applied to painting a child's head

You can now apply these exercises to a portrait of a child, and see how well your eyes can work. Remember that the exercises are aimed at teaching you to use your eyes in such a way that you are aware of all the many exciting possibilities in a painting regarding tone, colour, and form. They are also aimed at making you understand completely a continually moving form and changing expression. They are not designed to provide a formula for painting children. If you were to follow a stage-by-stage formula (an extreme example would be 'painting by numbers' in which spaces are provided and the selection of colours numbered for the appropriate spaces), all the qualities of individuality would be lacking. Painting would become a trick and there would be no point in seeing. After all, you are not only copying; you are painting the character of the child and his different moods. How dull it would be if all portraits were painted in the same way and everybody had the same character.

I have mentioned the importance of studying portraits of children done by well-known painters. At this stage it would be useful for you to look at some of these paintings, bearing in mind what I have just written about retaining individuality. It is a curious fact that in comparing two child portraits painted in diametrically opposed styles, one's first response is to see them both simply as pictures of children, in spite of the fact that they are two totally different pictures. From this you can learn that it is easy to adapt yourself to accept a diversity of styles, and, more important still, that there is no set way of painting children. Obviously the fashion of the age dictates the style to a certain degree, but the great paintings have all got a feeling of spontaneity that is the result of an imaginative response to their subjects. And, of course, these painters are total masters of the techniques of seeing and applying paint. If you study a Victorian painting of a child, usually with large, dark, sad eyes, you should realise that it falls short of becoming an important painting because the

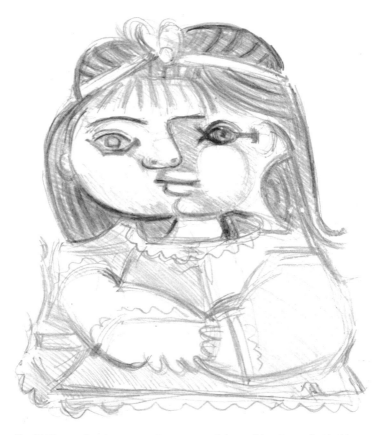

Fig. 25 Picasso. Here is a portrait that conveys all the qualities of a small girl without relying on any accepted ideas about drawing. This can only be done through a complete understanding of form and an ability to adapt technique.

Victorian portrait painters were slaves to the idea of what a picture should be like. Now compare two child portraits, one by Bronzino (fig. 27) and one by Renoir (fig. 50), (or pictures by two other painters of different styles—Picasso and Velasquez—figs 25 and 26) and see if you can discover some reasons why the paintings are so different and yet capture all the qualities that are the essence of children.

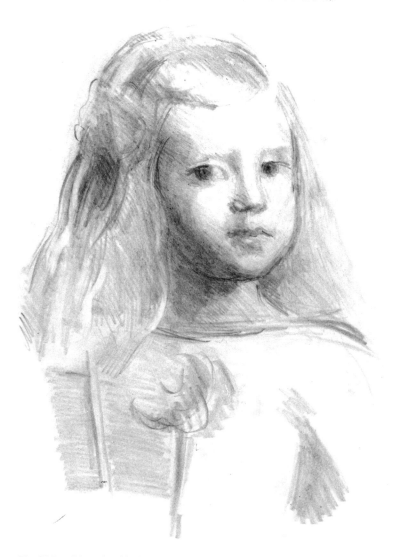

Fig. 26 Detail from *Las Meninas* by Velasquez. The onlooker is made to participate through the artist's intensity of vision. The softness of the hair and face and the proud expression are superbly painted.

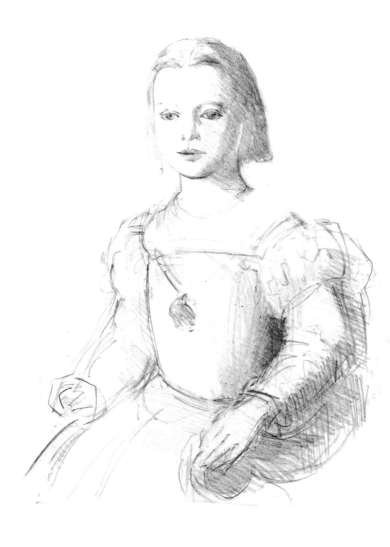

Fig. 27 Bronzino—portrait of Maria de'Medici. In many respects the prototype of the portrait by Velazquez. This portrait has an air of distinction

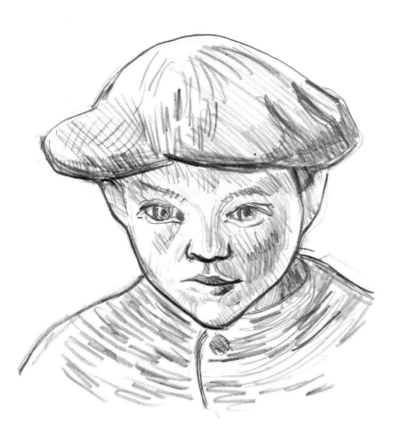

Fig. 28 Head of a Boy by Van Gogh. Shining through the strength and fierceness of technique is a haunted frail face. This is a portrait painted with intense emotion

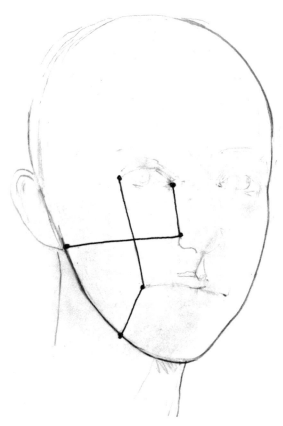

Fig. 29 Here I have marked four distances and directions that are very important to establish

Let us now refer back to the paper shape exercise and find out how it can help you to see a face. The exercise has shown how important it is to see areas in relationship. A very common fault (and one to avoid at all costs) is to assume that a face is composed of features only—nose, mouth, eyes, etc.—and, because a child's head has not the clear cut form of that of an old person, there is a particularly strong temptation to be attracted by these features. As it is the intervals between the notes that make a

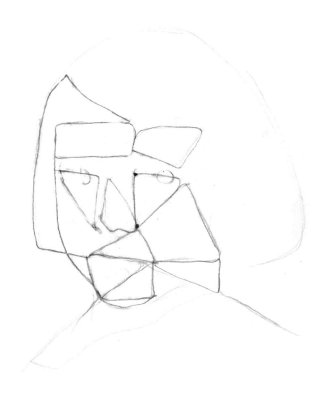

Fig. 30

melody, so the intervals, or spaces, between the features make a face.

You are not yet ready to start an actual portrait, but persuade someone to pose so that you can make the experiments that are to follow. You have discovered that the character of a two-dimensional shape is determined by the relative positions of the points where the enclosing line changes its direction. Now you must find the salient points in a face (obviously at least three

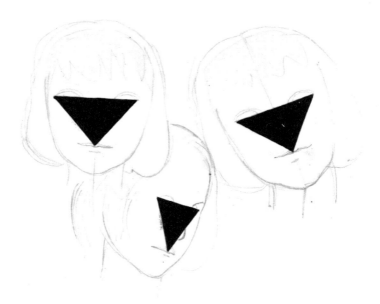

Fig. 31

which do not progress in the same direction, otherwise you will make a line and not an enclosed area). For example, you can make a triangle by taking points on the corner of the eye, the centre of the ear and the nostril. By looking for these shapes in this particular way you are creating a relationship of changing directions.

Try to find three such areas in the face and make sure that they are correctly spaced one from the other. You will find it difficult to paint three shapes and not paint any of the features of the sitter, but this exercise will teach you never to be seduced by preconceived ideas about a face, and it will force you to try to grasp some of the fundamental points to understand when look-ing at a head. Once you have established the proportion of a triangle—or indeed any shape—it does not really matter how big the shape is, or what position it has in relation to the paper. The

character of the shape will always remain the same. What matters is the relation of the three shapes to each other. To understand this is the crux of the problem of painting children's portraits. If you can fully understand these simple areas and their relationships, then it does not matter if the head is tipped this way or that, or even if the form is travelling across the room.

Finally, use the charcoal as we did with the paper shape exercise. Cover a sheet of paper with charcoal and rub out three shapes that you have found in the head (fig. 32).

How does the exercise of drawing chairs relate to painting a portrait of a child? The first part of this exercise has now been combined with the paper shape exercise, in helping you to construct a drawing of a head by building it up in terms of shapes and not in terms of features. Now remember the second part of the chair exercise. Rapid drawing without losing the strength

Fig. 32

gained by acute observation is another key to painting portraits
of children. Start with your pencil at any point on the face and
draw the distance and direction that your eyes travel, going from
one point to another, never at any time taking your pencil off the
paper and trying not to stop its flow. Set yourself the task of doing
five drawings, allowing only three minutes for each drawing. If
your time is up and you don't seem to have made much progress,

Fig. 33

stop, and start another. And whatever happens, don't spend time trying to make an accurate drawing of the features. Your aim is to have an immediate understanding of the fundamental shapes and proportions of a head, and—most important—to take the bull by the horns and push aside any fear that you may not be able to get a likeness, so that you are able to concentrate on understanding these fundamental shapes. It is impossible to decorate an Easter egg without making the egg first (figs 33–35).

Fig. 34

Next consider the application of the exercise of painting white bricks. We are now combining three things. Colour and tone must be seen in terms of shape, and you should now be familiar with the idea of looking for shapes in everything to do with a head. Remember that the white brick exercise forced you to see colour and tone without misinterpreting them, because you were painting unfamilar shapes.

Fig. 35

With pencil you drew the outside contour of the shapes; but with painting you must understand each shape and then look for the centre and push your colour outwards. You must not get into the habit of describing each shape and then filling it in. Still avoiding the mouth, eyes and nose, discover which shape is the lightest.

Obviously the difficulty here is that there may be several tones

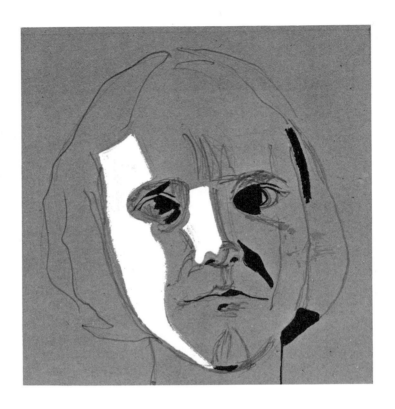

Fig. 36

in the one shape, but try to see the general overall tone and colour. Then look for the darkest, the warmest and coldest. Of course the lightest shape may have the coldest colour, so you can combine these in one shape. The end result of the painting should be a series of blocks in various tones and colour, in appearance like a Cubist picture, but obviously executed with a

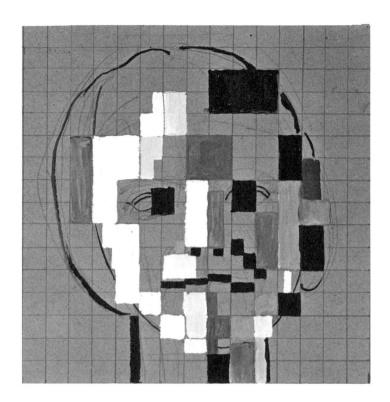

Fig. 37

completely different purpose. This approach to painting a head
will require acute observation and concentration. When you
tackle the portrait, you should be able to work with considerable
freedom between the two extreme limits of observation that you
have developed: one limit being a spontaneous approach (com-
pleting a drawing very quickly), and the other a deliberate and
calculated approach.

Fig. 38 A line has been drawn where the form changes from the front to the side. Note how the line is the same as the contour on the opposite side

Fig. 39

Lastly, consider the application of the apple exercise to paint-
ing a head. Your sitter will be able to move about as much as
possible. Analysis of the apple showed that the important fact
about a three-dimensional form is finding where the plane
changes direction. It is commonly assumed that the form finishes
on a contour; but the contour is the change of plane—in other
words, the point where the form turns away from your view.
Now, as a head is virtually symmetrical, it must follow that one
contour will indicate the change of plane on the part of the face
that has no contour—the part you cannot see. This must be fully

Fig. 40

understood if you are to do a successful painting. As soon as you have seen one contour, you can then work out the rest of the form even if the sitter is continually moving. An extreme example to illustrate this can be found in some portraits by Picasso in which he has drawn the profile down the centre of the face (figs 25 and 39).

You must now thoroughly inspect the head of your sitter. Look down directly from the top and find out where the widest part of the head is. Is it half way back, or more towards the front? If your model has a mass of hair, then feel for the widest part. Look up from under the chin and notice, for instance, that the mouth forms a semicircle. Now look down again from the top and see where the changes of direction are on the forehead. To be aware of all these changes in direction is important, not only for the

Fig. 41

reasons I have already mentioned, but also because these salient points are hard to find on a child's head, as the acute changes that are found on a skull are hidden, or rather smoothed over, by the scalp. Furthermore, the facial muscles have not had time to develop fully and the bone structure is not well defined. A portrait of an old man or woman is so much easier to paint as all the relative parts of the form are positively marked (fig. 42).

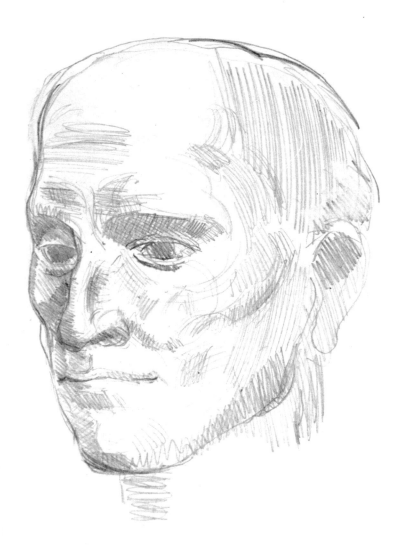

Fig. 42

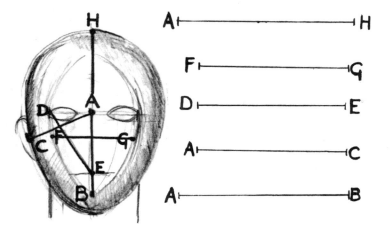

Fig. 43

When you actually start your first portrait it is not necessary
to go through all the stages described, but they must be carried
out as preliminary exercises and fully comprehended. Finally, to
understand what to look for in order to construct a moving form
and improve your faculties for visual memory, try working with
clay. With callipers measure the widest part of the head, from the
bridge of the nose to the back of the head, from the highest point
of the head to the chin, the distance between the cheek bones,
and any other important distances that you can think of. Transfer
these measurements onto paper, reduce the proportions to half,
and then try to construct a simple egg-like shape from these
measurements.

4 Character, pose, and composition

You will have understood from the previous chapters that to be successful with child portraiture you must develop a visual awareness so that you can instinctively assess relationships of tone, colour, and shape on a moving form. The visual awareness will also give you an opportunity to exploit ways of achieving spontaneity in your painting, and help you to develop an individual style. It is of paramount importance to be fully aware of your ability to achieve spontaneity when considering the character of the sitter. When we talk about the 'innocence' of a child, we really mean a child's spontaneous reaction to new emotions and discoveries. Your spontaneous approach will therefore create a positive link between your painting and the sitter.

We will begin this chapter by discussing various ways of detecting all the subtleties in a child's basic character and then relate these discoveries to colour, tone, shape, and the proportion of the canvas.

The face reveals character, but with a child the character is difficult to detect, as the features and surface forms are not fully developed. Neither emotional tensions and achievements nor sorrows and joys have left their mark on the facial expression. The child is naturally much more candid than the adult, who will often, by the way he moves and talks, assume a facade which hides his real character. However, unless children are in their natural environment, they also have a strong tendency to hide their true character. This is why you must look for the movements of the body. The child may hide his face and not realize that facts about his character can be understood by observing the movements of the body, and particularly the hands.

Before you begin to paint, look for a dominant characteristic. Is the child shy, forthright, sensitive or aggressive? We established the limits of a colour and tone scale, and can now begin to find a character scale. Obviously there will be many variations, but the

dominant note must be kept; and when adolescence is approaching the scale will become extremely complex. Having mastered the exercises in Chapters 2 and 3, you should be able to see your sitter as a complete unit. So watch for the relationship of movement between the head, body, arms and hands, and from them try to establish the dominant characteristic. For example, a child who lingers at the door to be introduced, and then tentatively sits on the edge of a chair and keeps his hands near his body, can be categorised as shy. The confident child will sit near you and will want to touch things. Make your deductions in this way.

The character of a person is shown partly by his choice of objects around him. So always watch what the child touches and shows interest in, and try to detect the make-up of his character by your observations. The clothes that he wears will often reflect the parents' character, and this will give you another clue to the child's character. So, as a rule, always paint the child in the clothes that he wears every day. It would also help to take note of the house that the family lives in. Every single clue to character must be fully exploited and used in your portrait.

No distinction is intended between boys and girls. Referring back to the first chapter, when I mentioned the danger of forming preconceived ideas, think how easy it is if, for example, you are painting a boy, to assume that he has less sensitivity than a girl; or that a girl is less aggressive than a boy.

While you are gleaning all possible information about character, there is no need to make any preliminary drawings. It would be better to let the child think you are not doing anything special. But whatever you do, be as natural as possible to ensure that you do not stifle the essence of your sitter's character. It would help to write down what you have deduced; in doing so you will clarify your ideas about his character.

You must discover a dominant characteristic to enable you to decide about the composition (the placing on the canvas) and the pose. There are three basic ways of placing the figure on the canvas: in the middle, looking straight out of the canvas at the painter; on the side of the canvas looking into the middle; and again on the side, but looking out of the canvas. With child portraiture you must make a deliberate and positive choice about

Figs 44, 45 Four different compositions that relate to four different types of character

character and then composition, as this is the true beginning of the painting. The difficulties of moving forms, changing expression and moods to which you will be subjected can be dealt with only if you firmly fix your starting point. You can establish another strong foundation for the portrait by deliberately relating the shape of the canvas to the character of the child. For example, a child with an extremely positive character could be painted on a square canvas with the figure right in the middle. (See figs 44 and 45.)

As hands reveal a great deal of a child's character it is always best to include them in the painting. Nervous hands, or hidden, closed, or open hands will add to the expression of character in the portrait. Like the head, the hands will be continually moving, so remember the exercises in Chapter 2 and apply them to the observation and painting of the hands. First look for the overall shape, then the shapes between the fingers, and then the relative positions of the nails and knuckles.

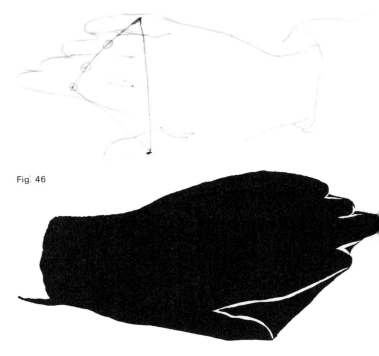

Fig. 46

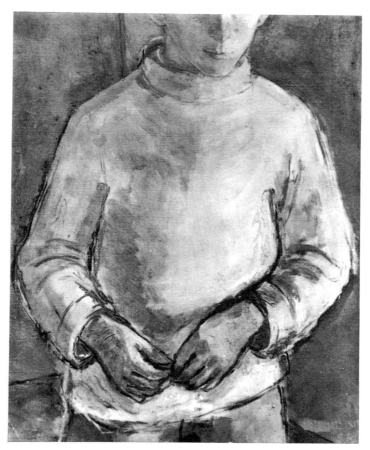

Fig. 47

Now you must relate the pose of your sitter to his character. This should be fairly straightforward, as each child will have a particular way of holding himself. Decide on the pose while you are thinking about the composition and the shape of the canvas; that is, when the child is unaware of being painted. The nervous child could be made to hold something small to join the hands

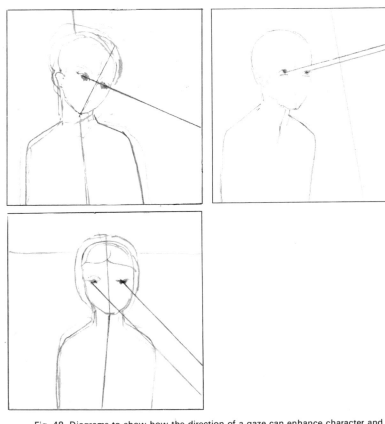

Fig. 48 Diagrams to show how the direction of a gaze can enhance character and add interest to the movement of the composition

together, giving the idea of diffiαence and nervous tension. To give the impression of openness, have your model standing as if walking towards you. As a general rule it is better to have the child standing and holding onto a chair or leaning slightly against something. This will keep the feeling of animation that is so

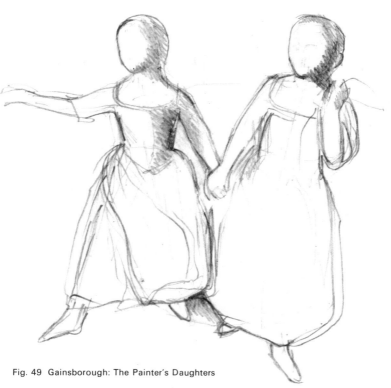

Fig. 49 Gainsborough: The Painter's Daughters

important to preserve in child portraits. If you pose the child in a chair, his tendency is to slump and so lose the feeling of animation. It is very important to think out a positive pose that will relate to the character.

Gainsborough painted a superb portrait of his two daughters, which demonstrates how the pose alone can give the feeling of youthful animation. The children are almost floating through the garden in a joyful, innocent dream. You would learn a great deal by studying this particular picture, which, I believe, is the best child portrait that has ever been painted. Renoir's Mesdemoiselles Cahen d'Anvers is also well worth studying to help you understand the importance of pose (fig. 50).

Fig. 50 The Mesdemoiselles Cahen d'Anvers by Renoir clearly shows how the pose can accentuate character. Note particularly the position of the feet

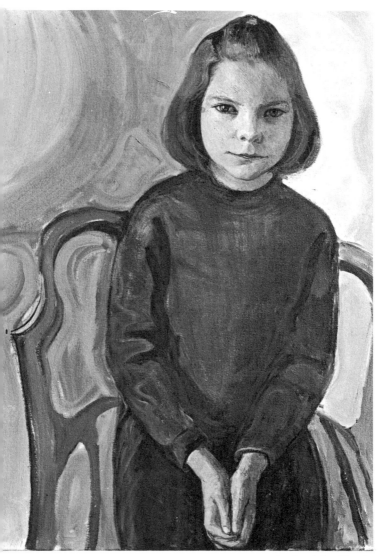

Fig. 51 With this portrait you can see how I have deliberately placed the girl at the side of the canvas. The position of the hands conveys an intense character. The flowing background is in contrast to the rather rigid pose

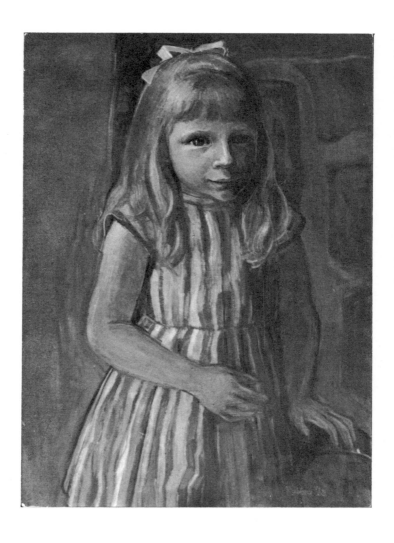

Fig. 52 Note the slightly hunched shoulders and position of the hands. An attempt to capture the moment when she is about to walk away

Fig. 53

Fig. 54

In order to give the painting a feeling of unity, it is wise to choose a predominant colour. You can decide on this, too, by relating it to the character of the sitter. For example, if you were painting a quiet child you could choose a pale blue. Obviously there is no set colour for a particular character—the choice is yours. The portrait will be enhanced because you will have made a positive statement regarding the relationship between yourself and the sitter. It is sometimes a help to prime the canvas with the colour that you have chosen: but more about colour in Chapter 6.

Much thought must be given to the way the light falls on the face. Having decided on the shape of the canvas, the pose, and the

Fig. 55 A very round head. The distance from the bridge of the nose to the ear is incredibly long. The direction of the light accentuates the shape

predominant colour, you must now use light to reveal the important characteristics of your sitter. An extreme example of how lighting can completely change the form and character of a face is when a light is shone upwards from under the chin. A familiar face becomes horrific and unrecognisable (fig. 53).

You must deliberately deduce the characteristic shape of the head and then adjust the light to enhance this particular shape. (If you supplement natural light with artificial light, then the artificial light must remain constant.) If the head is characteristically round, a light from above, right or left, would be most apt (fig. 54).

Fig. 56

As a general rule, it is unwise to have the face very light on one side and very dark on the other. Apart from creating shadows from the nose, too strong a light will destroy the subtle changes of plane which are so hard to find on a child's face. Similarly, on the dark side of the face these changes will again be lost. A strong tonal contrast will also make it difficult to see the head as a complete unit.

When painting a child's portrait, your approach should be as direct as possible, as the direct approach relates to the character of children. So always aim at putting your sitter where there is a fairly even light, but try to have a particular source of light from above the head. This will reveal the roundness of the cheek that is always characteristic of children. Think back to the apple exercise and remember that, however smooth the form, there are always definite changes in direction. So don't presume that you can paint a cheek simply by making a random series of tone changes from dark to light or vice versa (fig. 24). Look at some portraits by Leonardo da Vinci.

There are always exceptions to the rule. You may be painting a child with an angular and noticeably asymmetrical face. In that case you may decide to have a definite (but not too strong) light coming from one side.

With every aspect of child portraiture that has been discussed there has been an insistence on establishing a basic idea or starting point to help you to understand the relationship between moving and changing forms, and so avoid painting the portrait in clichés.

Finally, we must discuss expression. First, the expression is determined by the way a child thinks, so find out his main interests and talk to him about them. Second, the ways in which the eyes and mouth and nose change should not receive too much attention before you have understood the complete relationship between all the features and the head. Third, notice that when the eyes or mouth change expression the *shape* changes and, particularly with the mouth and eyebrows, the surrounding form as well (p. 64). Try to experience, and be thrilled by, the child's youthful animation, and remember that changing expression is just as important as the relationship of these changes with the movement of the head and body. Your eyes must work very hard indeed in order to see so many things at once!

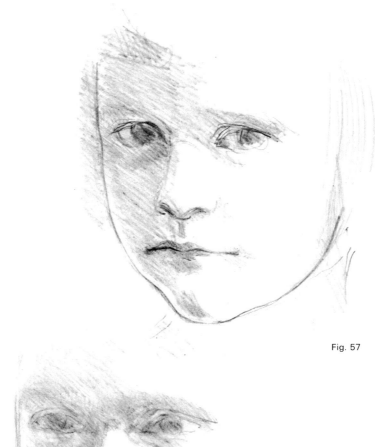

Fig. 57

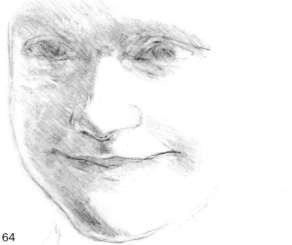

Fig. 58

5 The making of a portrait

I will try to describe how I painted a portrait of a six year old girl, and will explain my approach rather than the successive stages already described. It may be helpful to present a personal viewpoint and to show how I deal with the problems as they occur. My object is to help you to discover your personal way of painting children—not by giving you easy answers, for there are none, but by channelling effort in the right direction. Where is the joy of creating without having to try?

First I must make some drawings, so that I can discover important facts about form and expression (below and opposite). I dislike the word 'sketch', as it implies something superficial. I shall study how forms change when the mouth moves from the inanimate droop to the smile; the changing shape between the top lip and the nostrils and the changing shape of the eyes. I shall notice the characteristic shape of the head and each feature, and that the shape of my sitter's chin and forehead is similar to her mother's. Because I am familiar with the child's family and environment the task of assessing her dominant character is made easier, and therefore I am able quickly to form an idea about the pose (figs 61 and 62).

Fig. 59

over page Fig. 60

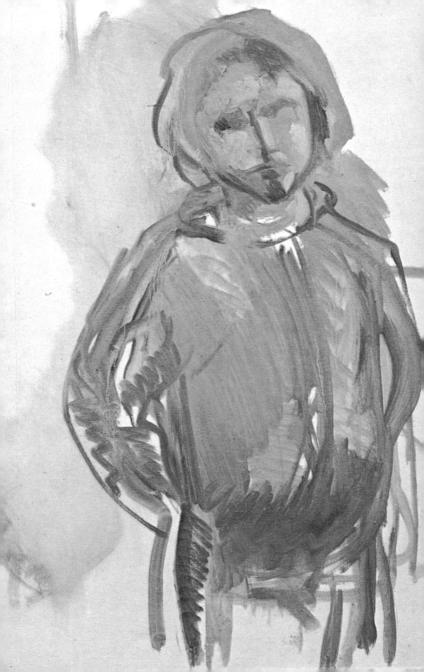

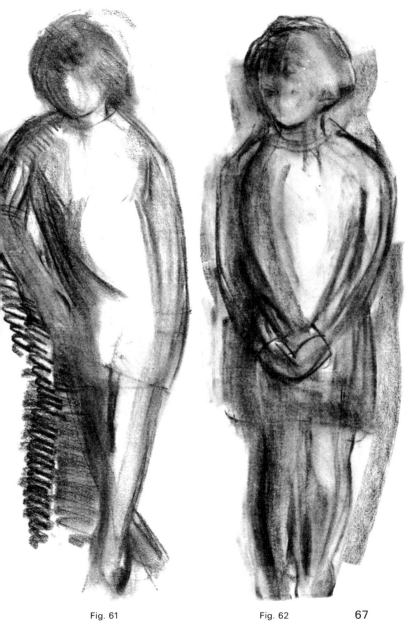

Fig. 61 Fig. 62 67

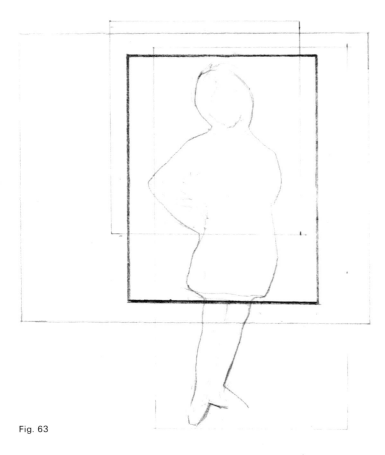

Fig. 63

I place the figure in the centre of the canvas, for this relates to her direct character. I want to include the body because I find the relationship between the frail body and the head beautiful. The arms will be tight behind her back to suggest the feeling of supressed energy—energy that will suddenly be released. I must take full advantage of this decision about pose, but before I begin the painting I shall try out different ways of placing the figure on the canvas.

Fig. 64

Having drawn a series of rectangles over a drawing of the complete figure, I am able to decide how much of the figure to include, the proportion of the canvas, and the exact placing of the figure on it. (The actual size of this canvas is 25" x 34".)

Now I can begin the painting. It is a mistake to start by drawing on the canvas with charcoal or pencil. This encourages a tendency to fill in the drawing, and inhibits freedom. With a large brush and enough turpentine to enable me to apply the paint freely, I quickly

Fig. 65

follow the rhythm of the body and head. The colour I have chosen is raw sienna mixed with white (see p. 66). The angle of the head has been established by thinking about the direction of the centre line (fig. 64); I am only concerned with the pose and the simple shape and proportions of the head and body. I have placed the sitter in my studio where there is light directed on to both sides of the head. This causes a darker tone to appear down the centre of the face and will show off the sweep of the nose and the shape

Fig. 66 Analysing the painting to show main rhythmical directions. Shaded areas indicate areas of Prussian blue

of the chin. A preliminary drawing of her profile has helped me understand the form of the face when it is facing me directly. By placing a dark area to represent an eyeball I shall be able to find

out how the character of the picture changes according to the direction of the gaze. This first stage has taken about ten minutes.

Soon I realise that my sitter is exceptionally restless. For subsequent sessions I must try to find someone to read to her. I cannot hope for more than five minutes' stillness per session, and it is essential to make her feel she is helping me by keeping as still as possible when needed.

With the next stage of the portrait I shall introduce a few more colours: vermilion to give cool colours of the face, burnt sienna for warm, dark colours and cadmium yellow for warm, light colours in the areas surrounding the body (p.76). As an experiment I have placed two patches of Prussian blue mixed with white diagonally opposite at the top and bottom of the picture. This accentuates the movement and thinness of the body by making the eye travel quickly up and down the picture. When looking at a picture, the eye will link up similar colours—the spacing and shape of the colour determines the speed at which the eye travels (fig. 66). The colour of her dress enhances the child's characteristic colouring and the style of dress simplifies the movement of the body.

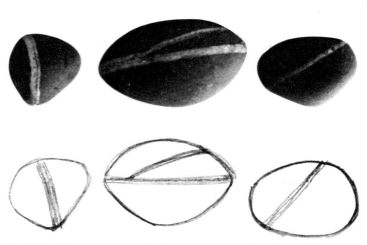

Fig. 67 Quickly look from the drawing to the photograph and you will soon see the inaccuracies of the drawing

Before I paint the features, I must accentuate the top of the head, tighten the arms, and push out the stomach. The eyes should be directed out of the picture as this will form a cross rhythm to the upward movement, exaggerate the chin, and suggest a possible shape for the mouth (see figs 48 and 66). It does not matter if I make mistakes in drawing and tone relationships. As my sitter is always moving, I must compare my picture with her when her position corresponds to it, and then it will become obvious what to correct. I am still trying to paint as freely as possible, still devoting all my attention to the main forms of the head. All the while I am searching for the characteristic shapes of eyes and mouth and how they change as the sitter's thoughts change. Before I begin the next stage (trying to establish the expression), all the proportions of the head must be accurate. I find it a help to look at the painting in a mirror. This has the same effect as seeing the picture with a fresh eye, and inaccuracies in proportion become apparent.

The drooping mouth (I have deliberately repeated the line in the shoulders) is too static. To make a portrait alive it is important to try to capture a moment of change. The body has been posed to suggest a feeling of impending movement, and so with the mouth I shall try and suggest a feeling of animation by painting the shape of it when it is about to move. I notice that, as the bottom lip draws in, the nostrils dilate slightly and the lower contour of the eye straightens. By pushing the hair back, I shall have a better understanding of the facial forms (fig. 68). I can now see the way the cheek bone turns away from my view, and how the brow joins the form of the cheek bone, and, more important still, understand the contour of the face. All the subtleties of shape, tone and colour must be fully understood, or the picture will remain static and not develop vitality. This is the most difficult moment. Everything is delicately balanced. An incorrect or careless placing of tone or colour, or a false accent of tone, will break up the form or change the expression. I always associate this moment in a painting with the sensation of seeing a landscape when the sunlight repeatedly bursts forth and then dies. This is the time when complete self-control is essential: emotional self-control so that I do not lose my ability to think clearly, and intellectual self-control so that I know exactly what colour, tone, or shape is

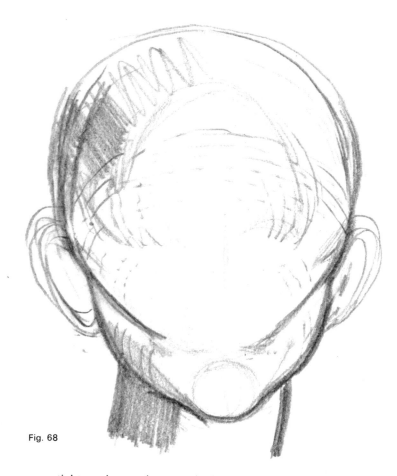

Fig. 68

essential to enhance the portrait. As I become more experienced in portraiture of this kind I know better what to reject and so am more able to paint a true portrait.

I am now able to work on the picture without the sitter in front of me. I have had plenty of time to remember all the essential forms and colours, and there is no danger of becoming biased by anything unnecessary.

The character of the painting relies to a very large extent on the colours and shapes surrounding the figure. As I work on the face without the model, I try out different colours and shapes over the background. The two areas of Prussian blue and white have served their purpose, but must now be eliminated as they distract from the simple shape of the figure. However, the upward moving shapes are still an essential part of the picture, so I will change the Prussian blue to warm colours ranging from orange at the base of the picture to yellow ochre at the top. By deliberately painting in blue stripes at an earlier stage, I have a much clearer idea about the colours that should be used, so again it is from mistakes and a willingness to experiment that I find the way to the completion of the picture. A suggestion of a line pointing to the elbow makes another cross rhythm to the upward movement and also draws attention to the position of the arm, but I must simplify the painting of the body even more (p. 77).

To do this portrait, I have had to combine intense observation with an ability to work emotionally, so that the result is a personal statement about another human being. People naturally differ in their feelings about children. Kokoschka's portraits, for example, are concerned with the frailties and pathos of children and are not obvious assessments of prettiness. To some, this idea may not have any meaning, but at least it is a positive idea.

Above all, tackle your portraits with enjoyment, enthusiasm and a sense of adventure.

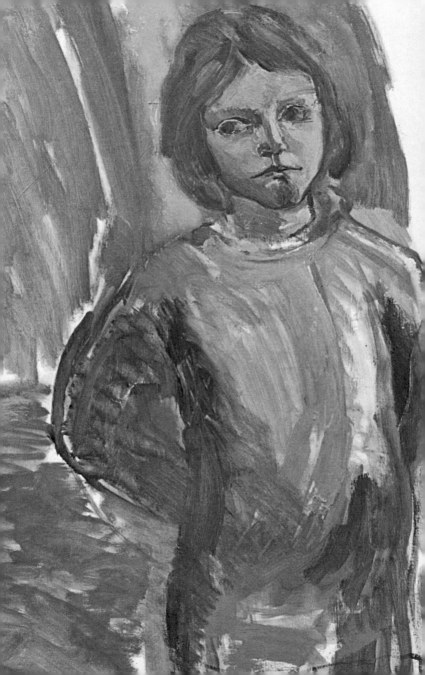

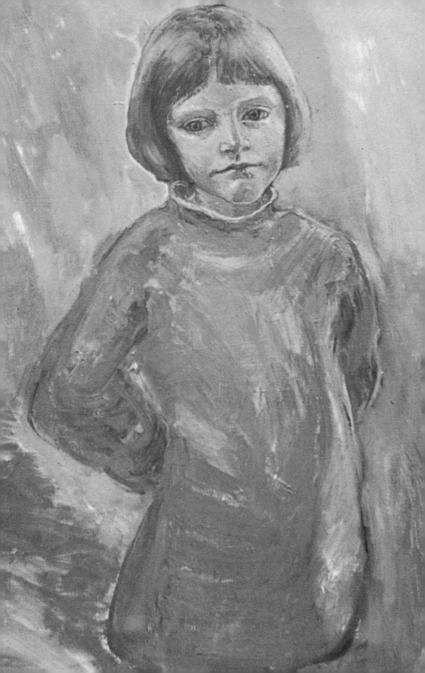

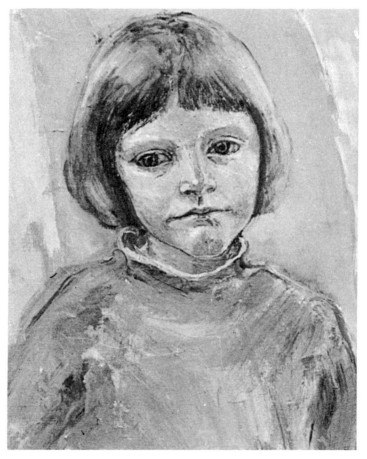

Fig. 71

6 Colour, background, and group portraits

The general make-up of a child's character (vitality, movement, and immediacy) must be expressed by the artist through an immediate visual response to form which can only be achieved with freedom of brushwork and technique. To achieve this freedom the painter must always be willing to try out new ideas and so keep his mind alive.

Colour

In a discussion of colour for child portraiture this flexibility of mind is particularly relevant. The more you are prepared to experiment the more you will be able to widen your 'vocabulary' and so discover positive ways to relate yourself and your painting to the sitter. A lively mind is essential to all forms of painting. When painting children it is of paramount importance, as your subject is full of life and unexpected changes of form and expression. It would be wrong to give you a set of rules to be followed with unimaginative rigidity, and I think my main job must be to try to plant seeds of creativity in the reader.

I have mentioned how important it is to choose a predominant colour that is relevant to the character of the sitter. As a student of painting you have learnt about the basic characteristics of each tube of paint. You will know that white makes all colours cooler (and, of course, lighter), and that yellow makes colours warmer (and lighter in tone). Viridian green will deepen and intensify cool colours, and crimson will deepen and keep the richness of warm colours. One colour can enhance another. Any green will spring to life when put beside a mixture of crimson and white, as will vermilion and white against yellow ochre, or mauve against cerulean blue. For a face that is predominantly pale and cool you could use a mixture of white, vermilion and raw umber, and then make this colour vibrate by painting the area around the head with patches of yellow ochre and vermilion. In contrast, for a rugged and tough little face use white, burnt sienna, and cadmium

red and, for the surrounding area, white, viridian green and crimson. You are not aiming to imitate the precise relationships of colour that you actually see, but creating something from the knowledge of what colours will do and then applying this to the portrait. To become really familiar with colours and how they react to one another, mark out a series of squares, and then paint one square with white and blue, another with white and viridian, and so on until you have used all the colours in your paint box. Continue by substituting yellow for white. Pair off colours that you find produce an exciting relationship, and keep this colour chart beside you when you paint a portrait.

Form and colour must be closely related. The form and surface changes on a child's head are soft, and therefore harsh colours and tone relationships must not appear in the portrait. Much can be learnt by studying child portraits by Renoir. His greatness lies in his ability to convey on canvas his love for the sensuousness of skin. The choice of light on the skin brings forth all the qualities of softness, and the choice of warm colours relate to the soft form of the subject.

If you are painting a child with an exceptionally soft face, try not to imitate what you actually see, but choose a colour range that will give you colours which relate to these soft forms—for example, white, yellow ochre and burnt sienna will produce a variety of soft warm colours. If you understand the actual colour relationships, you can then change the colours and make the effect more appropriate to these forms. In other words, the colour relationship is the same, but each colour has become relatively warmer or cooler. If you use yellow instead of white to lighten the tones and to add warmth to colour, then add yellow too, or crimson or Indian red, to the darker tones. Here we have another very important key to painting children—closely linked with the idea, in Chapter 3, that by understanding proportion we are able to change the size in relation to the paper without losing the character of the shape.

Freshness is a quality that must be conveyed in the portrait of a child, and the only way to ensure that your colours are fresh is to be certain that you never mix more than three colours together.

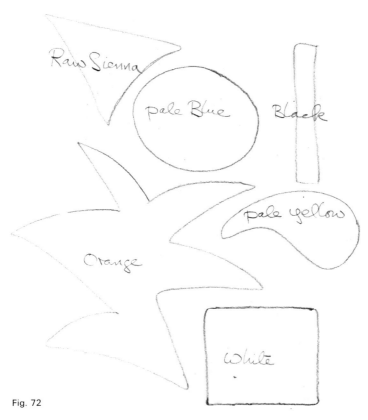

Fig. 72

If you mix complementary colours in your endeavour to get a colour correct, each one added will kill the properties of the previous one. Try a new palette arrangement, completely different from what you have been used to: for example, white, cadmium yellow, vermillion, and blue-black; or Indian red, viridian green, and lemon yellow. In fact, limit your palette to the minimum. Be careful of ultramarine blue; unless you are extra careful this colour will tend to make the mixture dead. Not only will a limited palette give you fresh colours, but it will also automatically give the painting a feeling of unity.

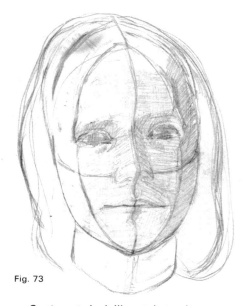

Fig. 73

So the rule is deliberately to choose your colours to relate to the child's character – warm colours and tones for a soft face, and a contrast of warm and cold colours if the face is angular and asymmetrical. Remember you are painting an instant in a human being's life which passes so quickly that you must make the most of all that is there; and by exaggeration and change you will convey something specific about character which will give a feeling of individuality to the portrait.

To pursue this particular idea about using colour, it is necessary to refer back to the paper shape exercise. Pin up some more shapes this time, including contrasting ones, and try to find colours that will be relevant to each shape (fig. 72).

Tone changes

I will now suggest some ideas about the use of tone, but keep in mind what I have said about form and colour. Looking for tone changes should provide you with information about the structure

of the form you are painting. Once this knowledge has been gained it is not necessary to imitate the tone changes. For example, have a positive light so that the structure of the head can quickly be understood; then make some quick drawings, just marking where the planes change direction (fig. 73). When you start the portrait, you can then paint each plane with a variation of warm colours all of the same tone, and so overcome the difficulty of observing and painting tone changes on a moving form. By channelling your knowledge of form into the use of these warm colours in the way I have described, the portrait will gain strength and radiance.

I must repeat that it is all too easy to guess tone colours and forms because of the constant battle against so many odds. If the portrait has been commissioned, the temptation is to take short cuts in order to get a likeness; and if your model never keeps still, desperation may lead you to work with preconceived ideas. Here is a maxim: with child portraiture you must be prepared to change what you see, but change with thought.

Background

We have talked about finding a predominant colour, the shape of canvas, satisfactory composition and tone to relate to your assessment of the child's character. I will now go a stage further and suggest ways of choosing a background. I think the word 'background' is misleading, as it suggests a part of the picture that is unimportant. This is not so. A background (I use it for want of a better word) must be seriously considered. First, it can accentuate character. For example, a restless character could be portrayed against jagged shapes and restless colours, or a gracefully moving child with flowing and rhythmic lines relating to the movement of the body (fig. 74). Secondly, it is fatally easy to rely on the relationship of colours and shapes already provided. So try to make a positive choice about colour and shape (see p. 76), or, remembering the child's character and environment, change the background into recognisable shapes that you feel will suit the mood of the painting (fig. 75). Gainsborough and Reynolds are two portrait painters who should be studied with this idea in mind.

Fig. 74

Groups

There will come a time when you will be asked to paint a group portrait. With a group portrait you are primarily painting character relationships. The painting of each individual child should be approached in the ways I have already suggested, but there is a

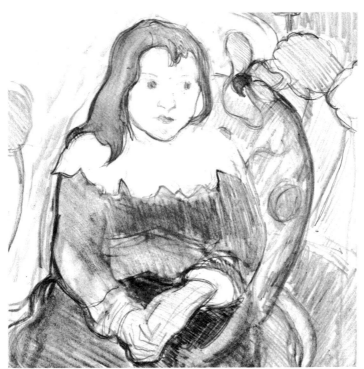

Fig. 75 This portrait by Gauguin illustrates how it is possible to choose a background that you feel relates to the sitter or sitters. Perhaps you would prefer to have a group of toys, or set the group in a landscape. In the painting on p. 87 I have chosen a background of colours and shapes that relate to each of the children

particular way to begin the picture. First, you have to work out the composition in terms of flat areas. So discover the shape, or silhouette, of each figure and from these shapes compose a pattern. It would help to cut out of paper each individual shape and then shift these about on a flat area until you have an exciting composition. You must, of course, decide on the pose in the way I have previously described before you work out the silhouette. Instead of the character of the child, it is the pattern that the silhouettes make that will condition the shape of the canvas.

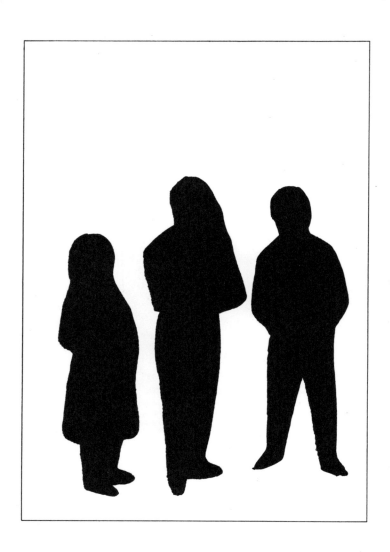

Fig. 76

Fig. 77

A good composition should convey movement, either in line or mass. If you can discover a rhythmical link by letting your eye travel from a shoulder to a hand, or from the tilt of a head to an arm, you will have formed a basis for your composition. Here again we can refer back to the exercise on drawing with a continuous line. Arrange your sitters as you have arranged the silhouettes, and then look for, or draw, a rhythmic line to link up the shapes and, if need be, slightly alter each pose. For example, tilt a head or extend an arm.

It is important to compose your background to accentuate or help the rhythmic pattern, as well as to consider a colour/character relationship. As you will not be able to have all the sitters together

Fig. 78

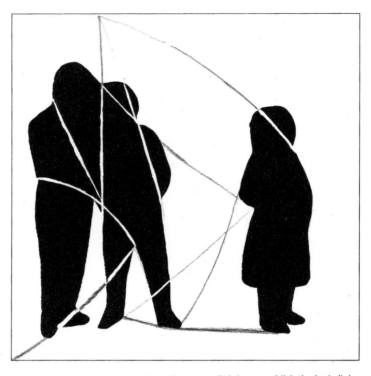

Fig. 79 Showing how you can adjust the poses slightly to establish rhythmic links, e.g. from shoulders to feet. Alternatively you can make a design with lines and then fit the silhouettes within the lines

throughout the painting, it is essential that you have the compositional structure of the painting firmly in mind before you begin. Character relationships are an important part of your portrait, so think carefully about the space between each child. For example, you can isolate one or join two together, according to character, simply by the distance between each figure. The juxtaposition of character, shape, and expression should give you many very exciting possibilities to make an interesting painting.

The childrens' comments about the painting could be helpful and interesting, so encourage them to talk.

7 Different media

Oils

The malleability of oil paint provides a wide choice of possibilities in the treatment of texture, colour, tone, etc. You may wipe, scrape or build up the paint without losing the positive quality of the painting. Parts of the picture can be *impasto* and parts can be scraped to reveal the ground colour (fig. 80). But what is it about oil paint that is particularly relevant to painting children?

It is not a contradiction to talk (as I have done earlier) about the importance of spontaneity and then to say that oil paint can be worked and worked until you are finally satisfied—which implies an unspontaneous approach. What must be done is to choose a way, or ways, of applying the paint from the wide range of available possibilities so that your choice relates to the character of the child. My recurring theme is that in order to keep a quality of individuality and spontaneity in your portrait you must, by a series of personal choices, relate yourself to the sitter. The choice of how the paint is to be used and what aspect of the child's character you will portray is far more important than being conditioned by a series of rigid rules.

The following are a few ways of applying oil paint, from which you can make your choice. The characteristic softness of a child's skin can be conveyed by the technique of glazing. This is done by applying an impasto layer of, say, a cool colour, allowing it to dry, and then painting a warm colour over it (mix some linseed oil with the warm colour). If you then wipe off enough to reveal the colour underneath, the effect will be rather like the bloom on a plum or like the 'transparent' colouring of a peach. With this particular technique in mind it is worth studying some child portraits by Rubens. Another method is to paint freely and thinly over the predominant colour you have chosen, so that this underlying colour will remain between the brush strokes and parts will show through the thin paint. You can apply the paint in different ways in the same portrait. Rhythmic lines, on the arms for example,

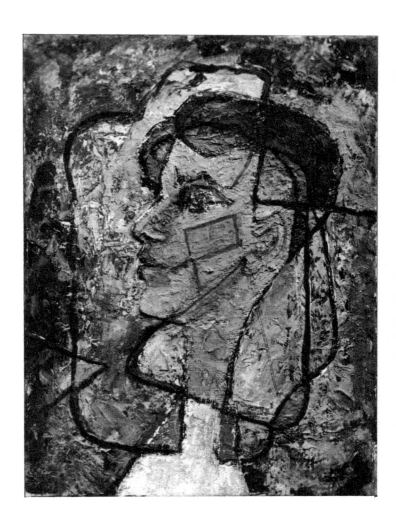

Fig. 80 *Robert* by Nell Todd

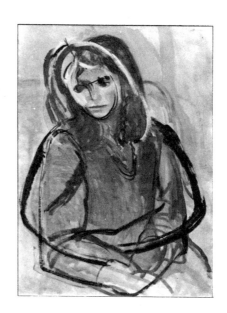

Fig. 81

could be emphasized by boldly wiping the paint with a rag; and the soft glow of the face emphasised by painting in layers of transparent colour.

Keep your painting alive by using unexpected techniques. Oil paint should be fully exploited to give movement, subtlety of character and of colour—all of which are vitally important in child portraiture. Above all, do not lose the feeling of freshness by thoughtless paint mixing—but I have already discussed the importance of a limited palette and restrained mixing.

A final word of advice. Always be prepared to change the painting—maybe a slight tip of the head or the position of arms and hands (the joy of oil paint is that you are able to change). If you prevent yourself from altering when the desire to change is in you, then you will be making a false statement about what you are seeing and feeling (fig. 81).

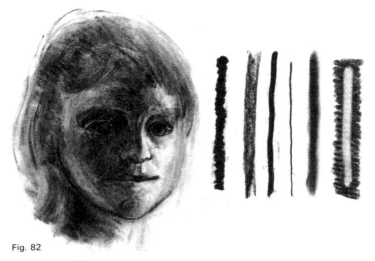

Fig. 82

Add the names of Van Eyck and Rembrandt to your list of painters to study. These two great artists should help you find out more about exciting ways of using oil colours—the richness and depth of Rembrandt (particularly one of the portraits of his son Titus) and the fineness and intricacies of Van Eyck.

Acrylics

The various techniques for oil painting can also be applied with acrylic colours. However, as these paints are quick drying there is less chance of the colours becoming muddy through excessive mixing as the paint is being applied. Acrylics are ideal for a quick study, as you can immediately paint on any non-oily surface, from unprimed canvas to newspaper. Rapid drying facilitates the technique of glazing. You can work quickly, so a feeling of spontaneity is more easily achieved. On the other hand, you must be careful that the colours do not become too harsh and the texture insensitive. Acrylics are certainly versatile. They can be used with water, gloss or matt medium, or with texture paste, and can be painted over oil paint. So use them to explore textural effects for backgrounds and clothing, to contrast with the softness of the skin.

Charcoal

When using other media, you must know their limitations before you can exploit them to bring out the essential qualities of a child. Perhaps the best medium is charcoal. Charcoal will produce a rich, positive, yet soft line. Its blackness in relation to the white paper immediately establishes the two limits of the tone scale. Within this scale you will be able to produce a wide range of tonal values, so that it is possible to exploit fully the gentle modelling of a child's head (fig. 82) and express the rhythmic flow of the body by a positive line.

Remember that you are now drawing whole areas, and that you are able to draw high tone areas with a rubber (gum eraser). (Refer to the exercises.) When you are looking for line, be aware of the different qualities that lines have. With charcoal you can, in effect, make a monochrome painting (fig. 83).

Oil on paper

If you have some proficiency in adapting your technique of seeing to painting children, and are able quickly to assess and understand form, then oil on paper is an apt way to interpret children. Use fairly hard and not too absorbent paper and prime with clear shellac to give the paper the roughness or 'tooth' of canvas. You can mix the shellac with dry powder colour, selecting the colour to relate to the character of the sitter. If you use paper instead of canvas, your fear of attacking a pristine canvas is removed and you are able to paint with more freedom. Always prepare several sheets of paper so that, if a satisfactory result has not been achieved with one sitting, you are able to start afresh. You will have gained experience from the previous attempts.

The oil paint must always be applied diluted with turpentine, working on the principle that the more diluted the paint, the lighter the tone. Build up the main forms of the head with thin, superimposed layers of colour. Always use unmixed colours (that is, straight from the tube) and rely on obtaining subtleties by mixing your colour on the paper. For example, if you want a green colour, do not mix yellow and blue on the palette, but paint an area of yellow on the paper, cover it with a layer of blue, and then wipe

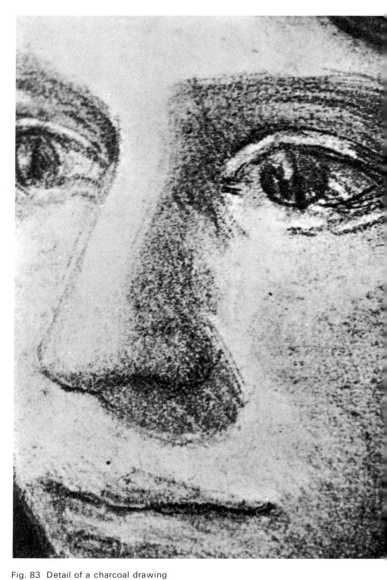

Fig. 83 Detail of a charcoal drawing

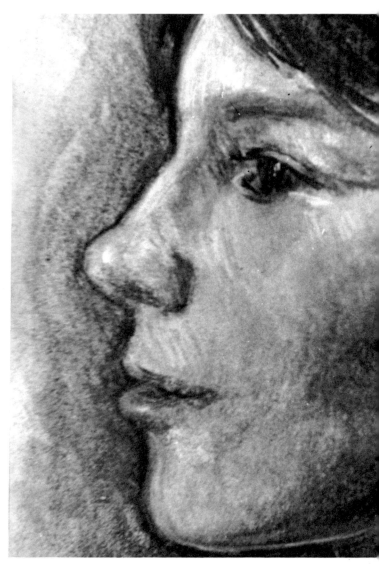

Fig. 84 Detail of oil on paper

with a rag and the green will appear. If you want the primed paper colour to shine through in places, use a rag soaked in turpentine to rub out unwanted colour. Finally, define the most important forms with a thin round sable brush (fig. 84).

Watercolour

Watercolour should be used primarily to convey atmospheric effects like the continually changing light of an English landscape, or even the scent of a rose. What should you look for when painting a child in watercolour? Not line or tone of defined shapes, but softness, radiance and light. The watercolour picture in its purest form is an emotional response to these things, rather than a study of form, tone and colour. I have not space to discuss watercolour in detail as a technique, and will only say that you should aim to apply the colour with complete control, sensitivity and spontaneity. It should be exciting to portray a feeling of radiance or softness by 'suggested' forms, colours and line, and to accept an element of chance effects. Try to complete a portrait in under ten minutes.

Pencil

The pencil is graded from very hard to very soft. A hard pencil must be used to explore intricate shapes and patterns, a medium pencil to exploit line, and a soft pencil to construct solid forms by drawing areas of tone. The type of paper you use must be carefully considered. For example, a soft pencil on rough paper would produce an effect similar to that in fig. 83. On hard, smooth paper you are able to produce crisp positive lines as on page 31. The four copies of paintings on pages 28 to 31 have been drawn with a soft pencil on the same type of hard paper. I have tried to adapt the technique to the different qualities of the four pictures. Having chosen your pencil and decided how to use it (that is, whether to draw lightly or chunkily, whether to use the point or the side of the point, and so on), select the type of paper according to your assessment of the child's character.

I have suggested that you can bring a portrait to life by varying the way you apply the paint. With a pencil portrait, try using a

variety of pencils. You might draw the delicate shapes of a hand or the folds in the clothes with a hard pencil, and then the head and the fullness of the cheeks with a soft pencil. Never assume that there is only one type of pencil and one way of drawing. The pencil is a basic tool of the trade, widely used and misused. It has an alarming way of revealing mistakes in the drawing and of accentuating any lack of sensitivity. So it is impossible to try to suggest line or form without considerable knowledge about the structure of what you are looking at and the way you are seeing. On the other hand, because of this particular quality, a pencil is invaluable for carrying out exercises; exploring the structure of a head, the reason why tones change, and a host of discoveries that will be useful when you start a portrait in oils.

Mixed media

It becomes increasingly obvious that the essential aspect of child portraiture is that you must make a deliberate attempt to establish a basic attitude towards the character of your sitter and then choose not only the appropriate colour, pose and composition, but also the medium and the way it is to be used. The more experienced you become, the more you should experiment, for by experiment you keep your mind alive and your eyes open to all the changing subtleties of a child. Try mixing techniques—oil and gouaches, or oil and oil pastels, or watercolour and chalk. The permutations are endless.

8 How to deal with your sitter

In this section I will write briefly on how to deal with your sitters so that you are able to make the most of their characters and expressions, and how to control their movements. First you must realise that all children are different and therefore there is no single solution to the problem; but it is more important to have an interested and animated child than one who is dull from being forced to keep still. However, if the portrait is going through a difficult stage, the frustrations caused by an unco-operative sitter can be overwhelming and often disastrous. So here are a few ideas that you may like to adopt, always bearing in mind your own character and response to children.

First, you must try to make the child feel that he is being useful by posing for you. As the painting progresses, show him each stage and explain how it was possible to paint the eyes, for example, because of his co-operation. As you paint, tell him which particular bit you happen to be working on. All this will establish a basic understanding and interest and so help to stabilise movement, mood, and expression. If you can find someone to read to the child (which I find most helpful), let the sitter choose the book. Expression is stabilised, but there is enough change to watch and paint.

I suggested earlier that you discover the child's main interests. Again you will be forming a common understanding and therefore increasing the chances of co-operation.

I have not assumed any particular age. When does a child cease to be a child? As an artist you will find that the problems change when you paint adolescents. The difficulties of painting a moving form diminish, because the older child can sit still for longer. However, the character becomes more complex and harder to understand. So, instead of concentrating on ways to make your subject keep still, you have to find methods of establishing and stabilising a mood. This must be done by being as natural and direct as possible so that you form a simple relationship with the

sitter. When you meet again (there may be a week or more between each sitting), attitudes should not have changed very much.

The amount of time you allot for each sitting will of course vary from child to child. Try to strike a happy medium between the length of time during which the child will pose satisfactorily and the time you require to do the job properly. You should not succumb too easily to the whims of your sitter. You are the boss, and it is better that the child should think that you are conferring a favour on him by painting him than that he should think that he is doing you a favour by sitting for you!

Fig. 85 Drawn with soft pencil

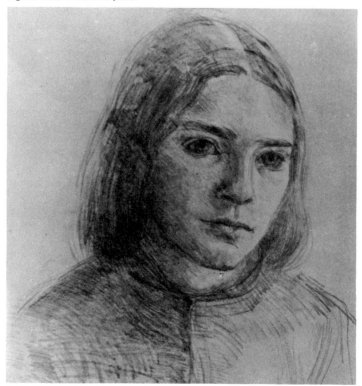

9 Conclusion

I hope that the ideas put forward will encourage you to venture into child portraiture. This book has been written to interest and 'launch' the student, rather than as a step-by-step guide or formula for painting children. It has also tried to make you increase your capacity for seeing. I have not gone out of my way to make things either easy or difficult for you. My purpose has been to open the door—and it is now up to you to develop your own approach.

Child portraiture has many difficult problems to overcome, but like all painting, and any worthwhile task, it is an exciting challenge. If the problems are not seriously considered, there is a danger that the portrait will degenerate into a sentimental cliché. It is easy to generalise about any subject, and yet extremely difficult to understand the complexities of changing forms, character and expression; so there is a great temptation to relapse into thinking about children en masse. Be particularly aware of this when assessing character. I have suggested ways of assessing a child's character, but it must be made clear again that these suggestions are purely a starting point for relating character to canvas. Your personal reaction to a character is the real beginning of a successful portrait.

Always be conscious that you possess a pair of eyes and keep them alert. If you are going for a walk in the country, try to see trees, clouds and hills purely in terms of shape and colour. Always be conscious about relative sizes. Increase your powers of memory by looking hard at something for a few minutes, then turning away and drawing.

To have the blessing of sight and not use it fully is a dreadful waste. Only with intensity of vision can you make an intense and vital painting.